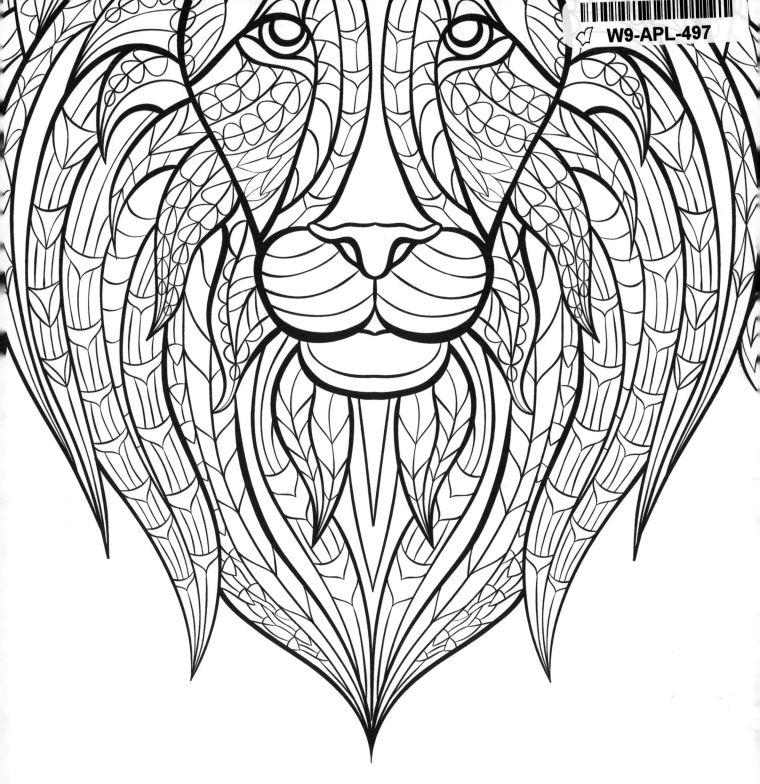

Adult Coloring Book™

Stress Relieving Animal Designs

Blue Star

Blue Star Coloring Books is in San Antonio, TX and Portland, OR.

Teamwork makes the dream work: This book was designed by Peter, written by Gabe and published by CJ. Adult Coloring Book, Stress Relieving Patterns and Blue Star are trademarks of PCG Publishing Group, LLC. The copyright © belongs to Blue Star as of 2016. We reserve all of our rights.

Thanks to Shutterstock for some stellar images, which we used under license. This book is proudly printed in the United States of America.

We Love What You Create

And We Want to Shout It From the Rooftops

@bluestarcoloring

facebook.com/
bluestarcoloring

@bluestarcolor

#bluestarcoloring

bluestarcoloring.com

Show Us
Your Art

We'll Show
The World

We'll never be perfect, but that won't stop us from trying. Your feedback makes us a better company. We want your ideas, criticism, compliments or anything else you think we should hear!

Oh, and if you don't love this coloring book, we'll refund your money immediately. No questions asked.

Send anything and everything to contact@bluestarcoloring.com

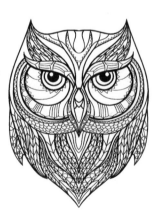

How to Use This Book

 Break out your crayons or colored pencils.

..

 Turn off your phone, tablet, computer, whatever.

..

 Find your favorite page in the book. That is the beginning.

..

 Start coloring.

..

 If you notice at any point that you are forgetting your worries, daydreaming freely or feeling more creative, curious, excitable, delighted, relaxed or any combination thereof, take a deep breath and enjoy it. Remind yourself that coloring, like dancing or falling in love, does not have a point. It is the point.

..

 When you don't feel like it anymore, stop.

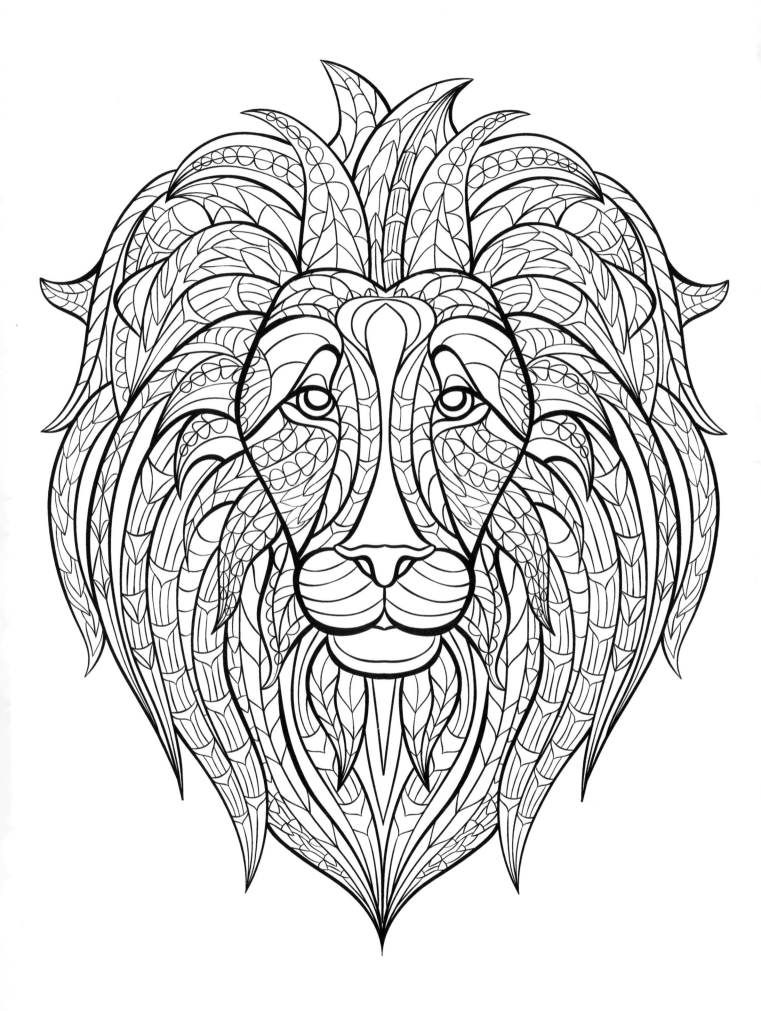

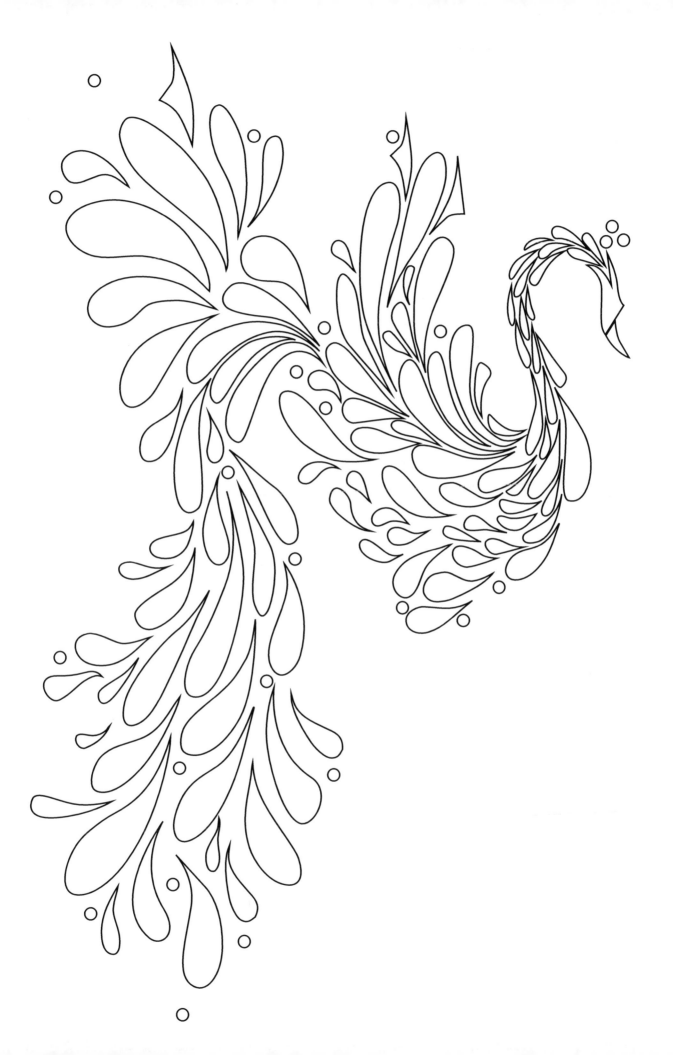

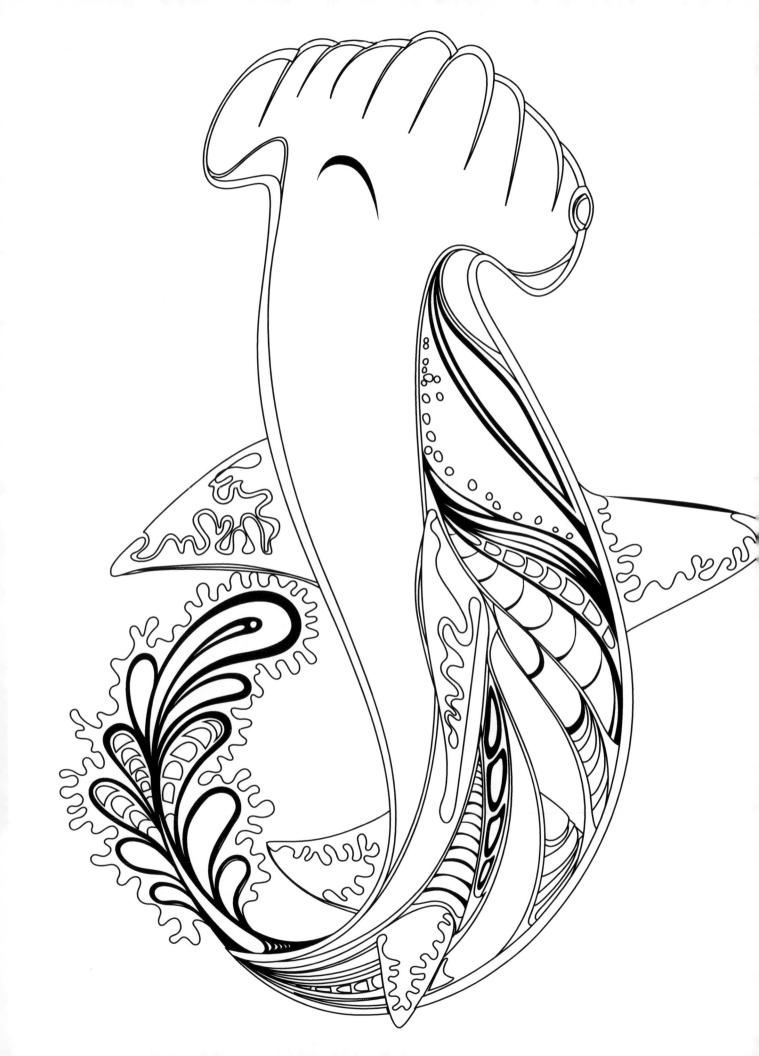

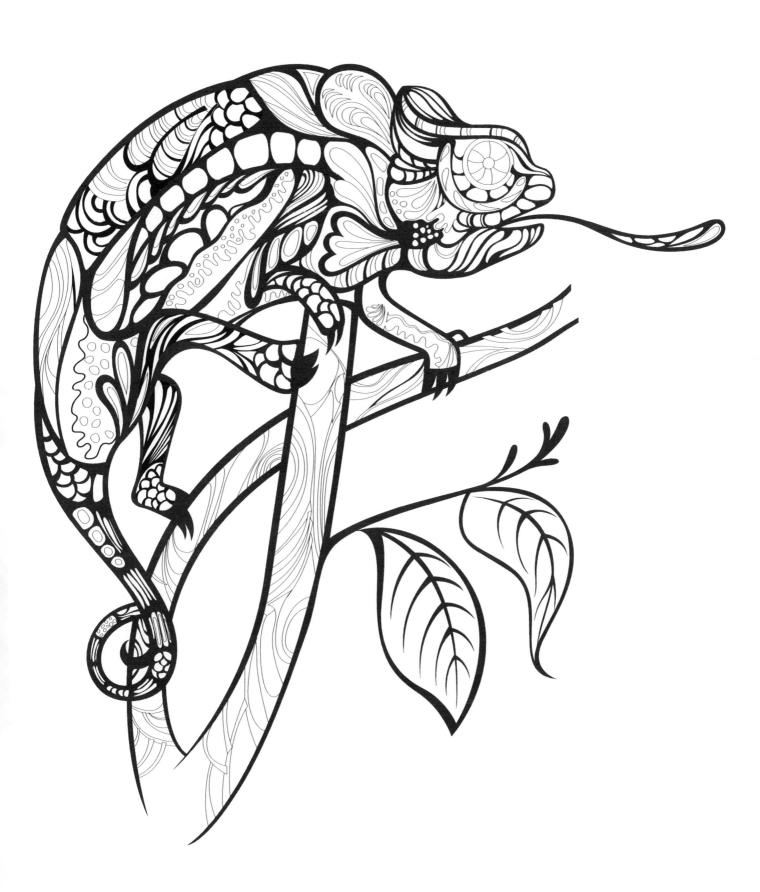

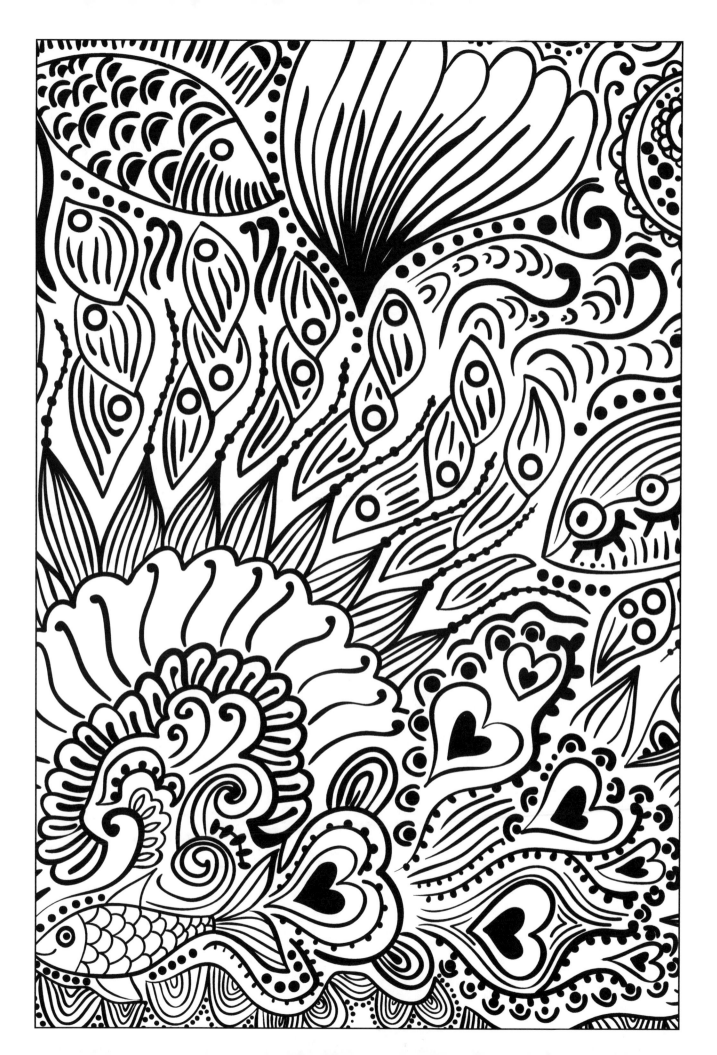

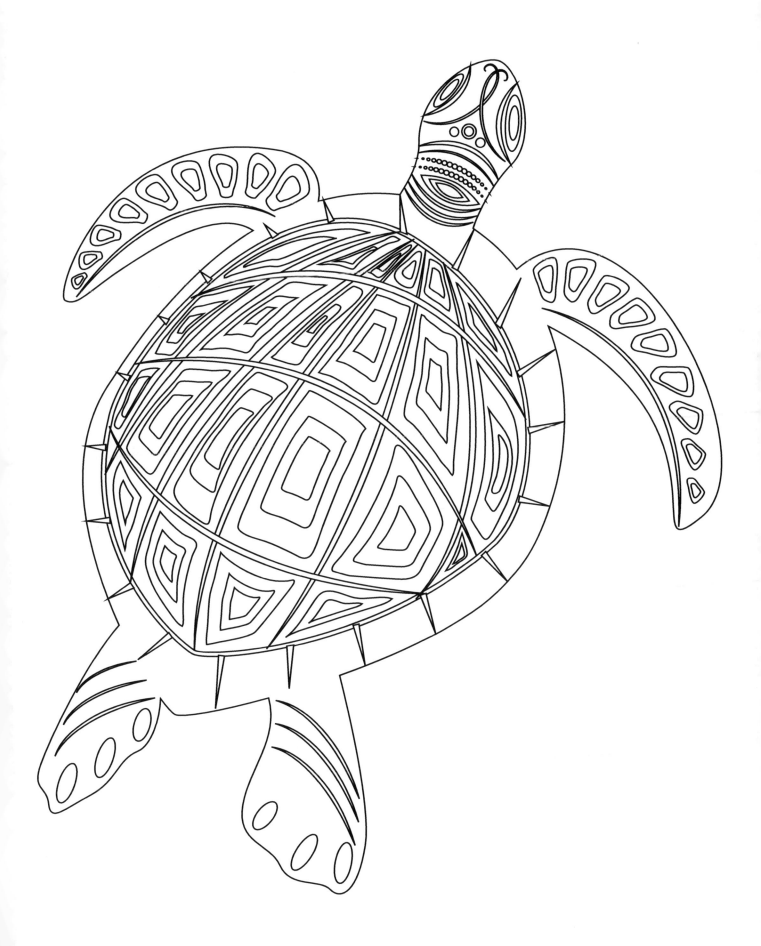

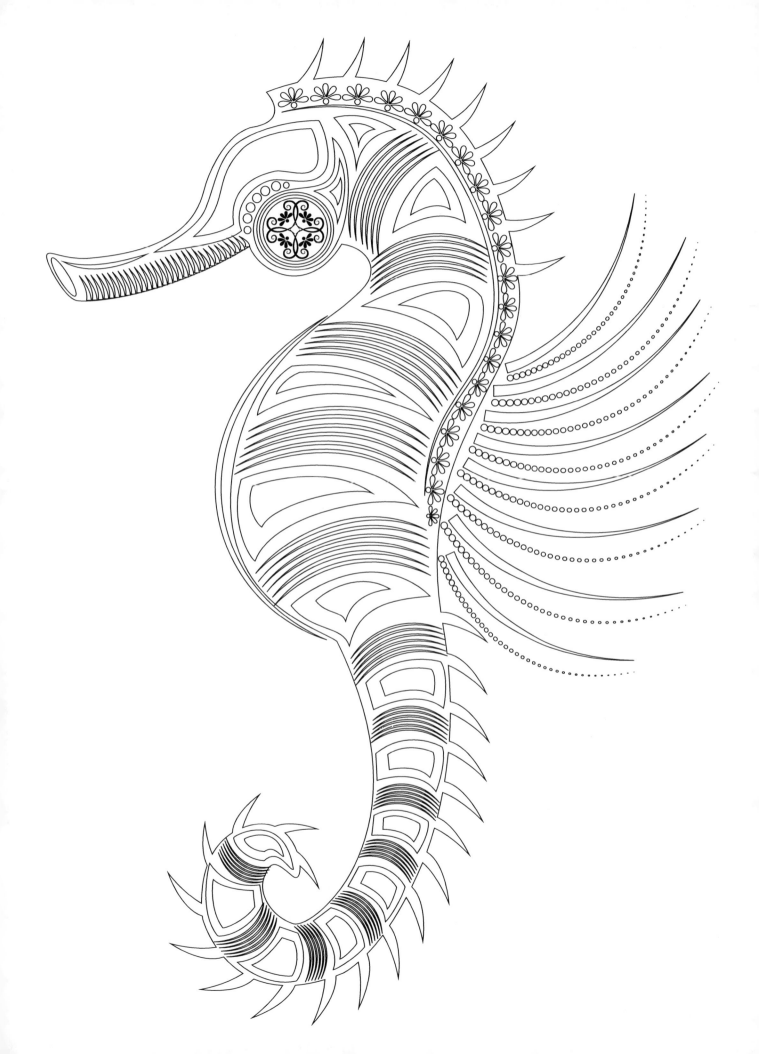

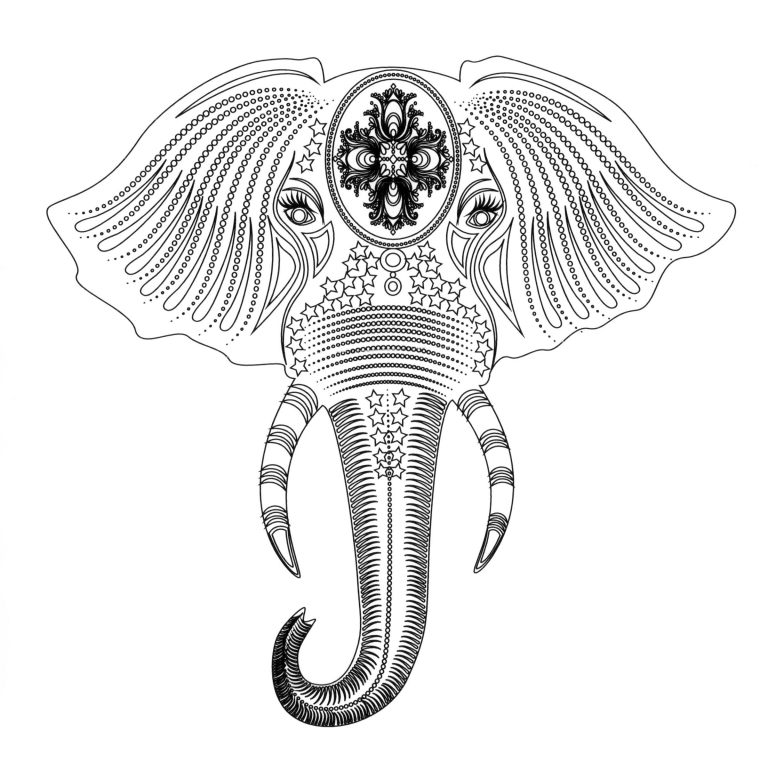

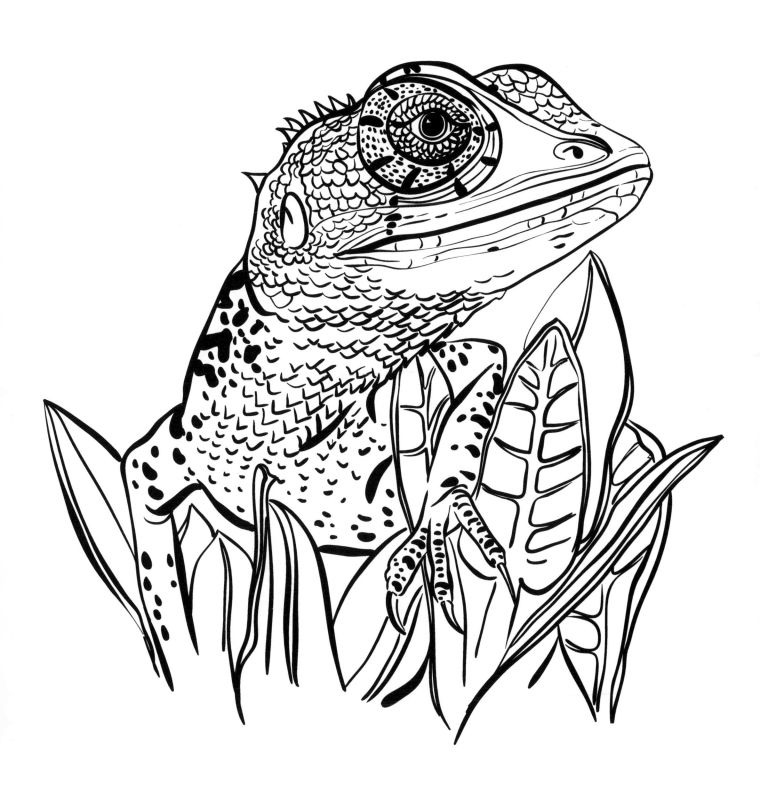

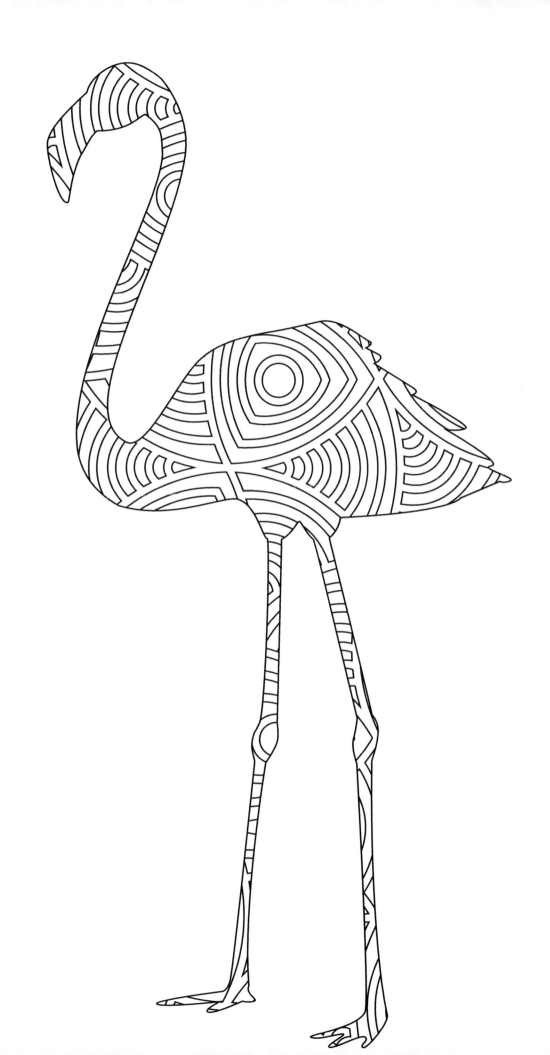

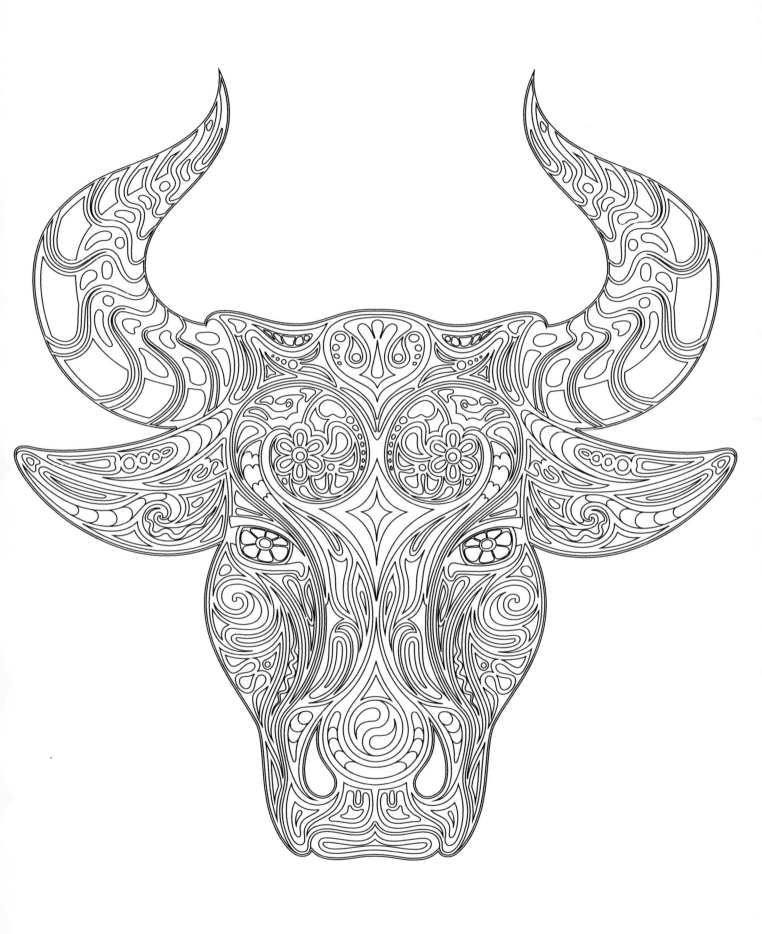

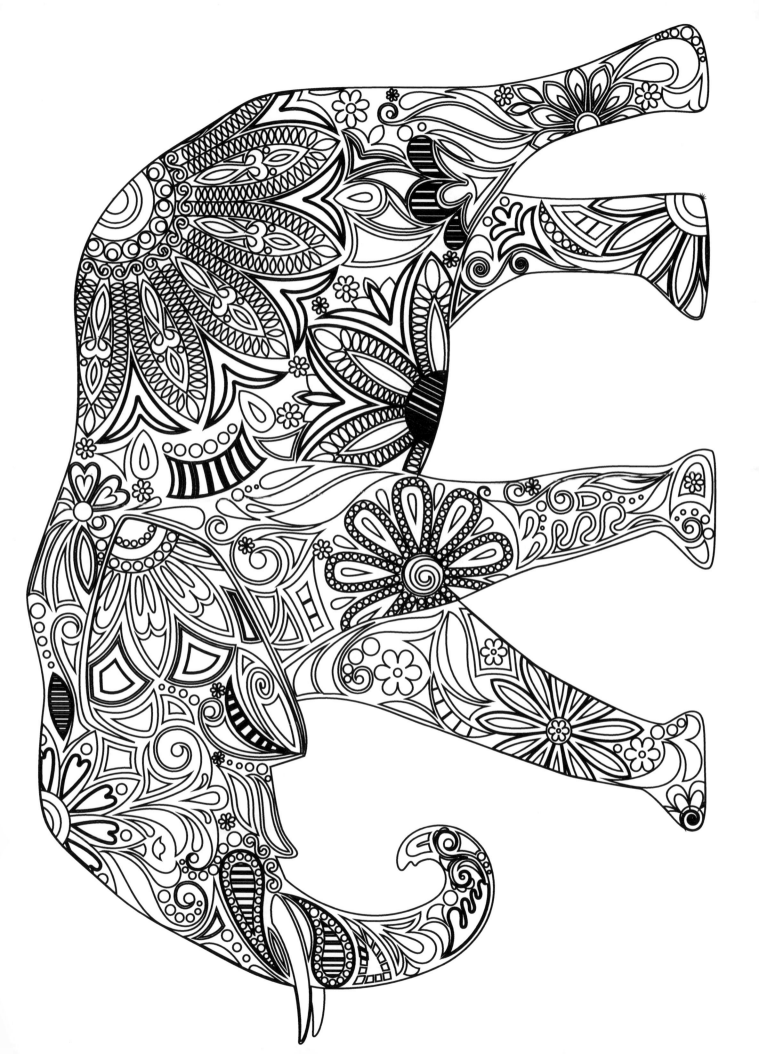

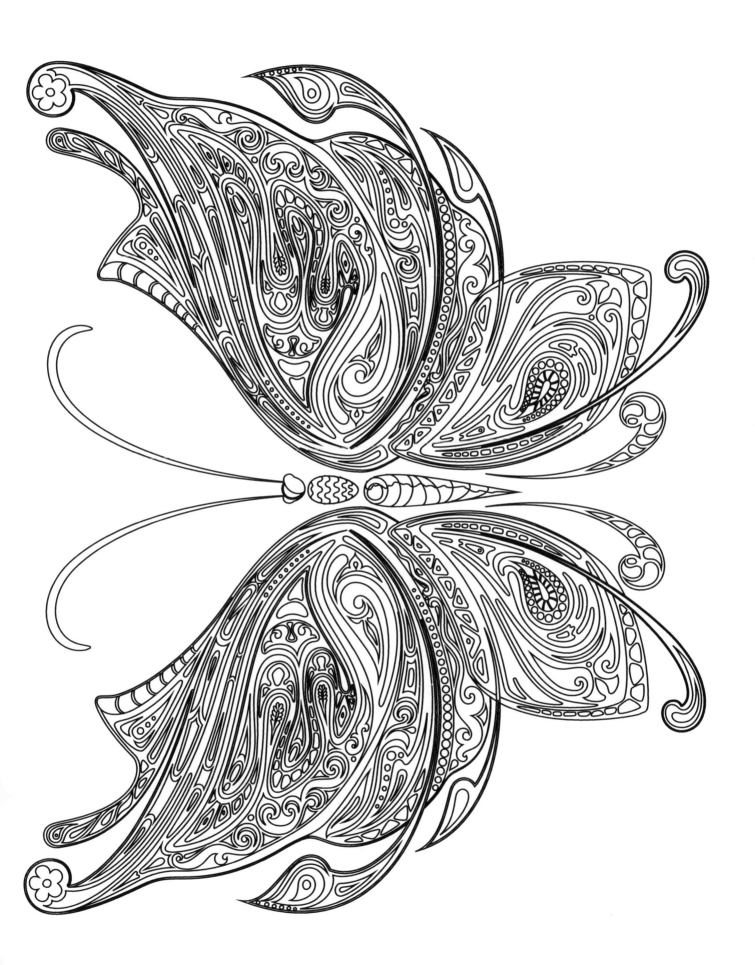

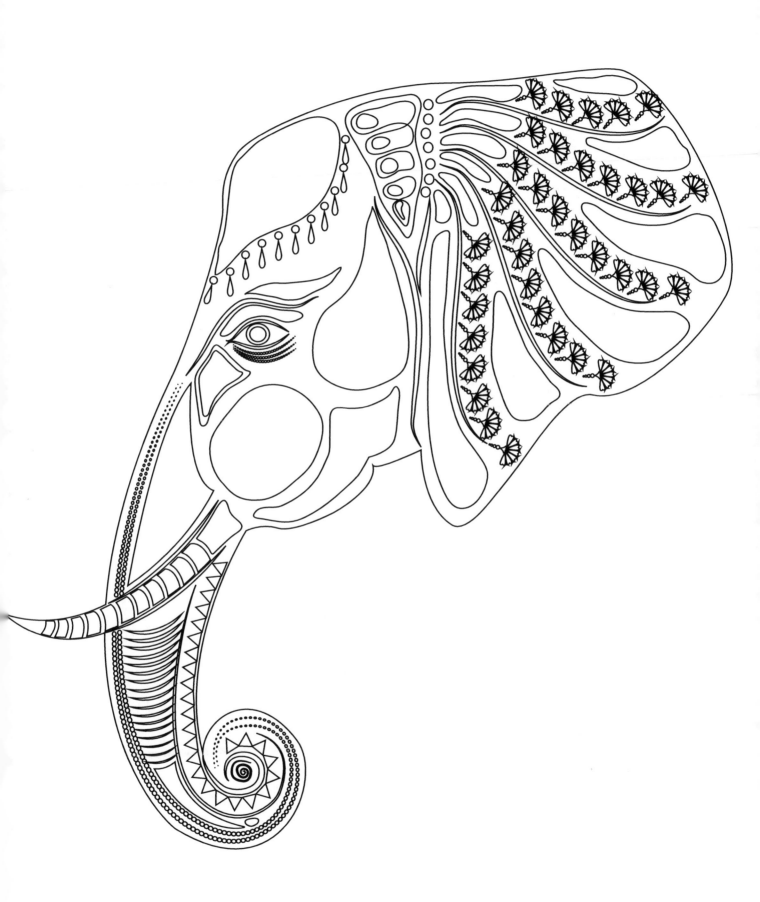

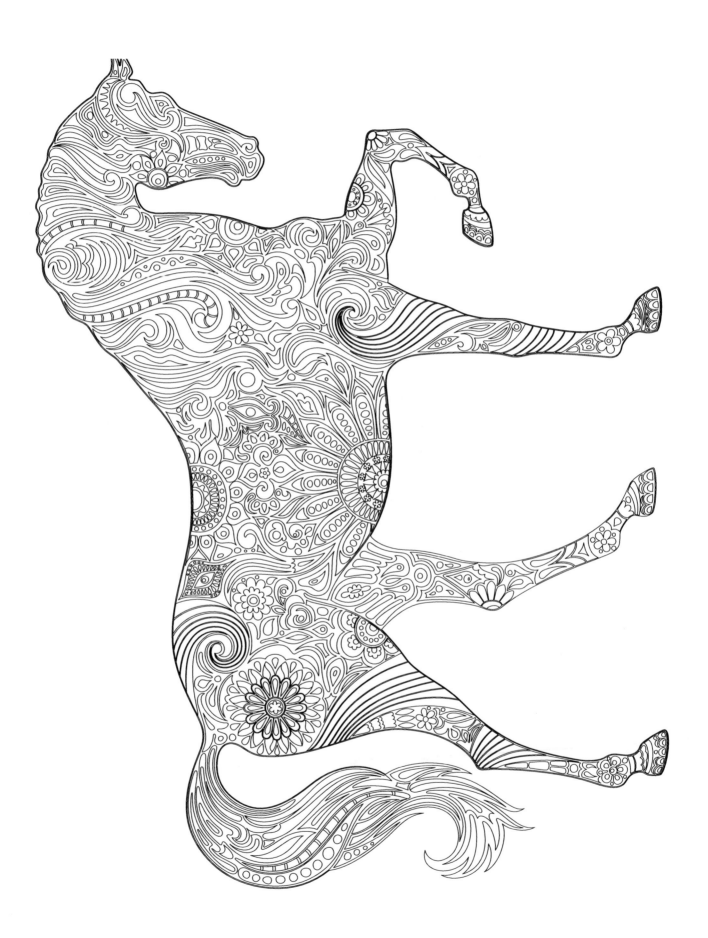

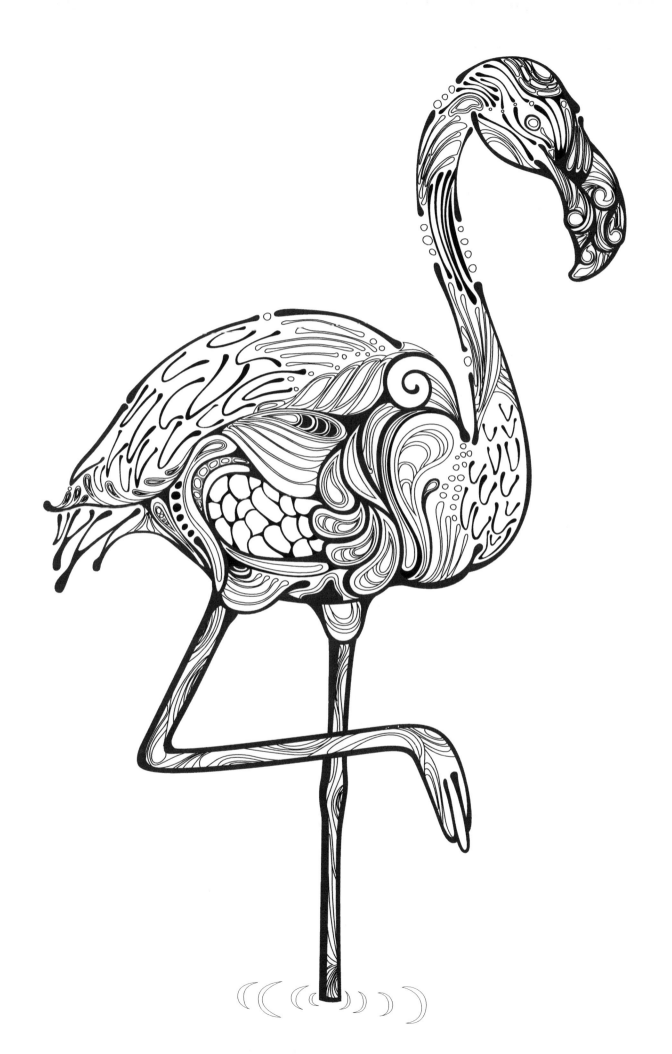

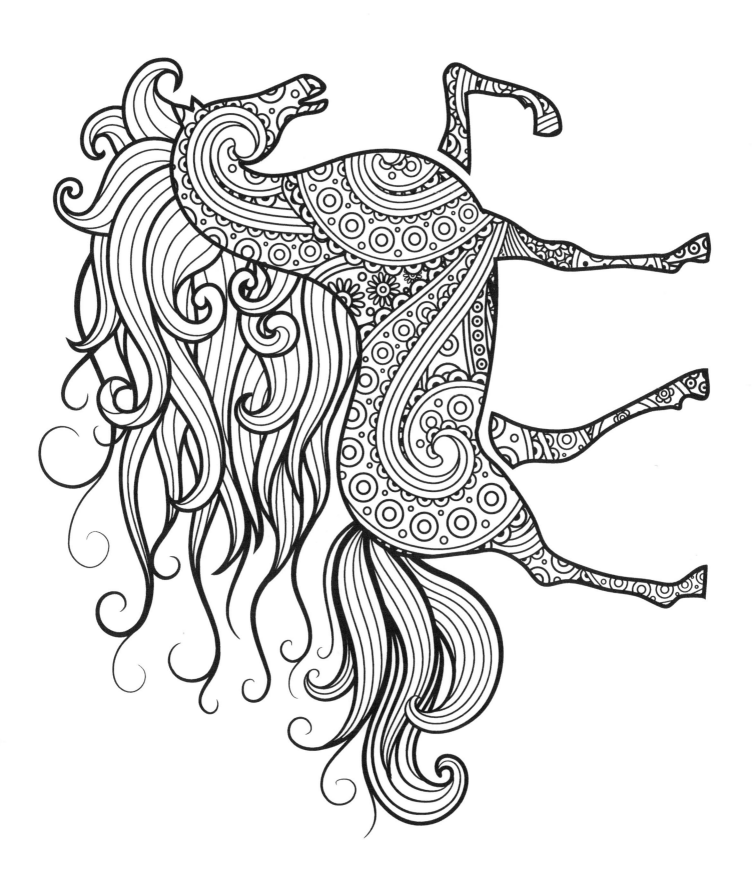

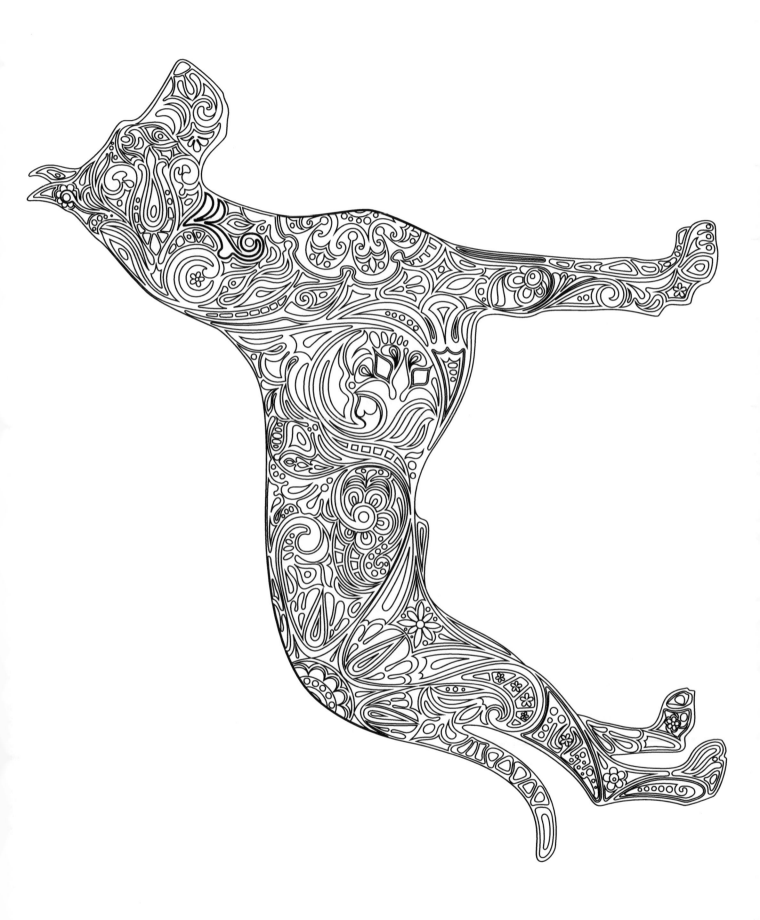

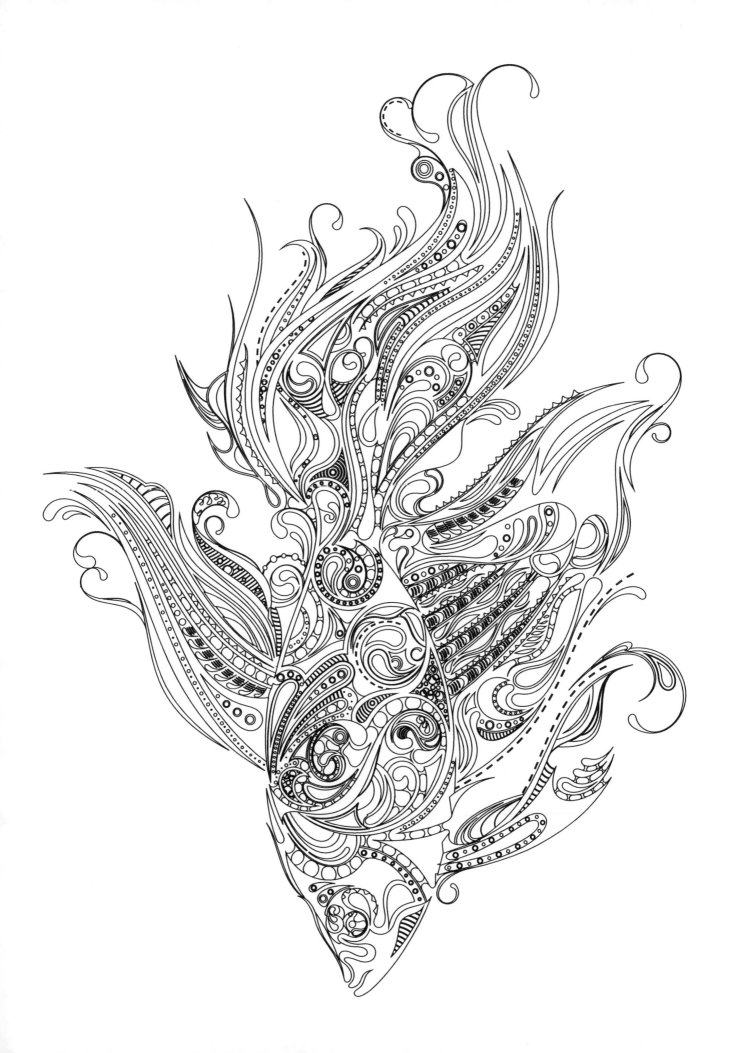

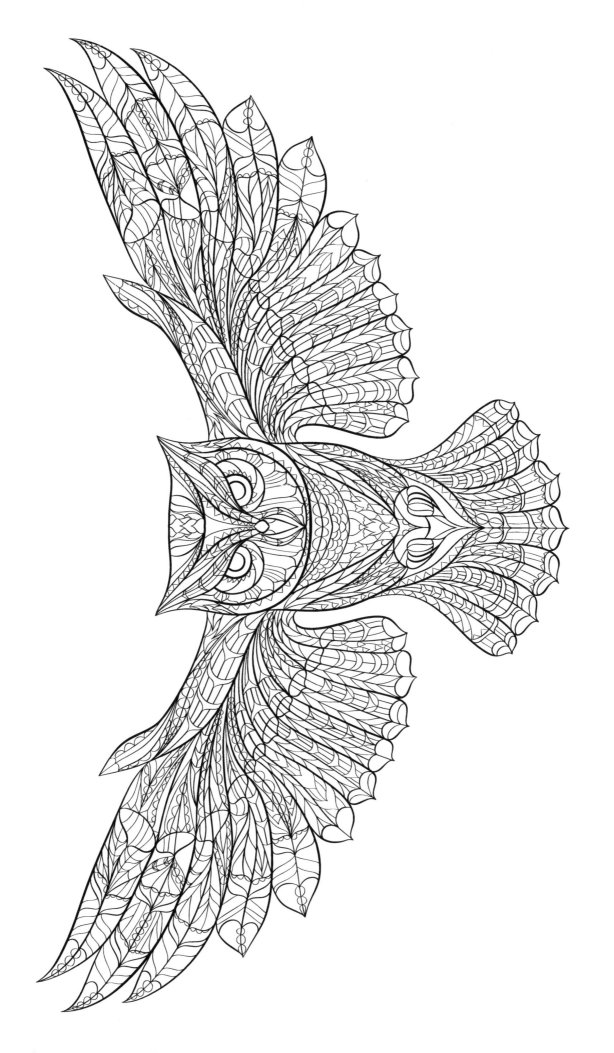

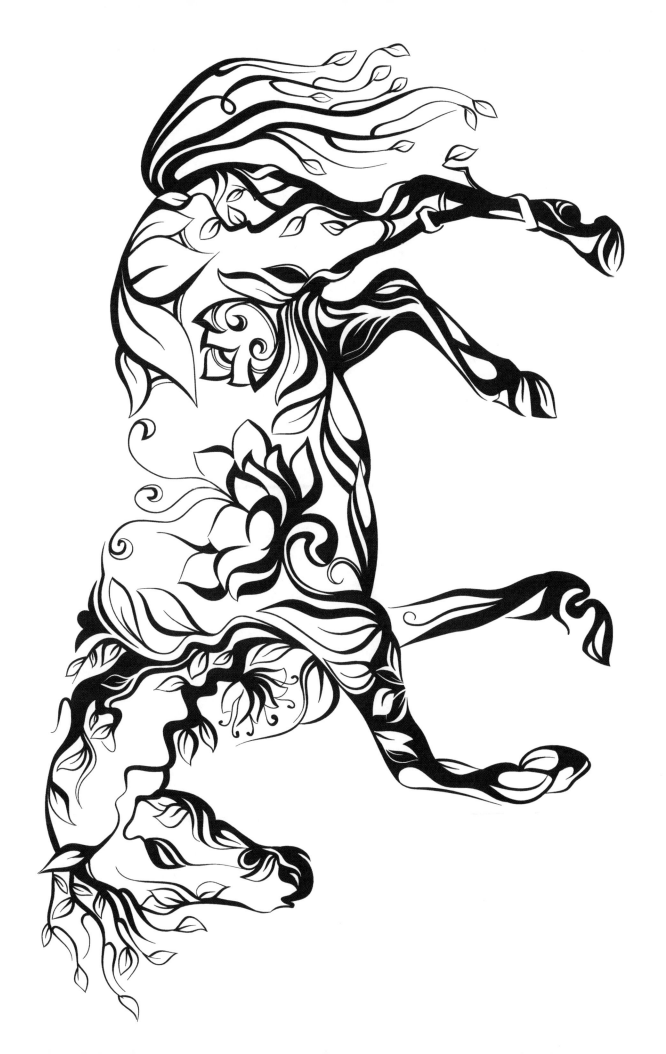

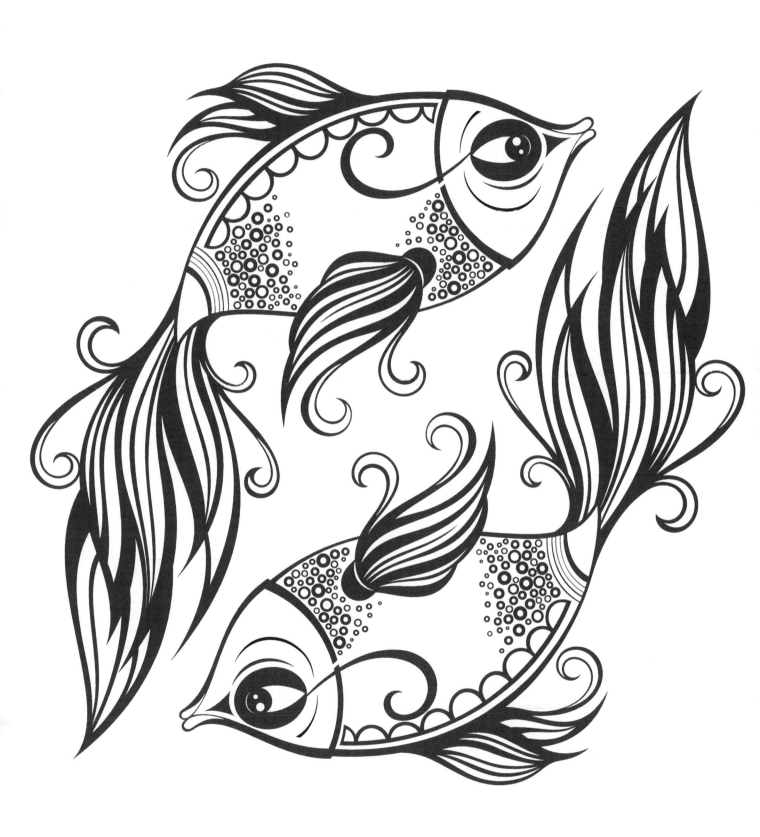

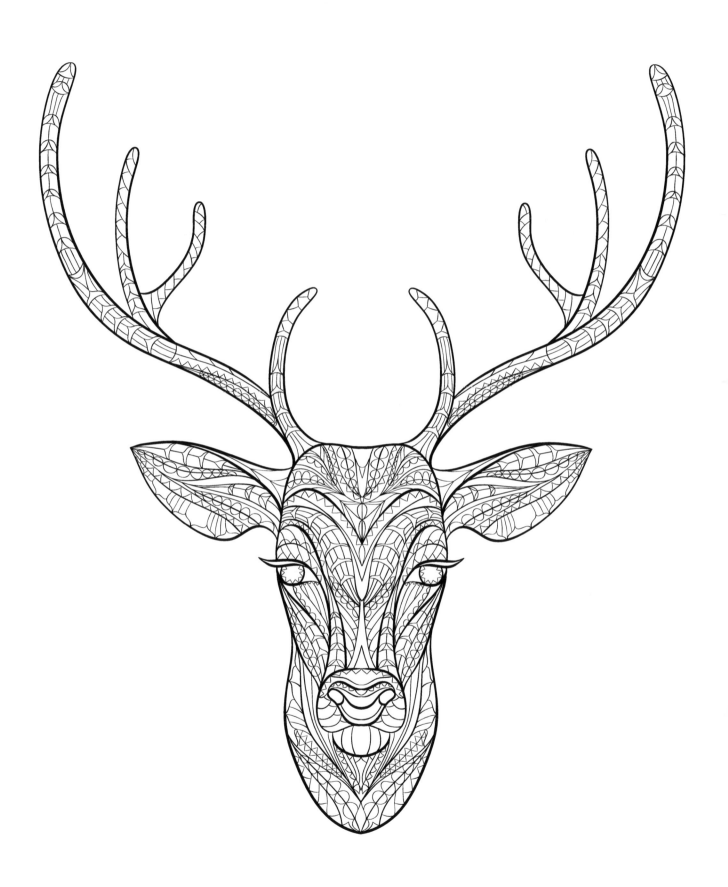

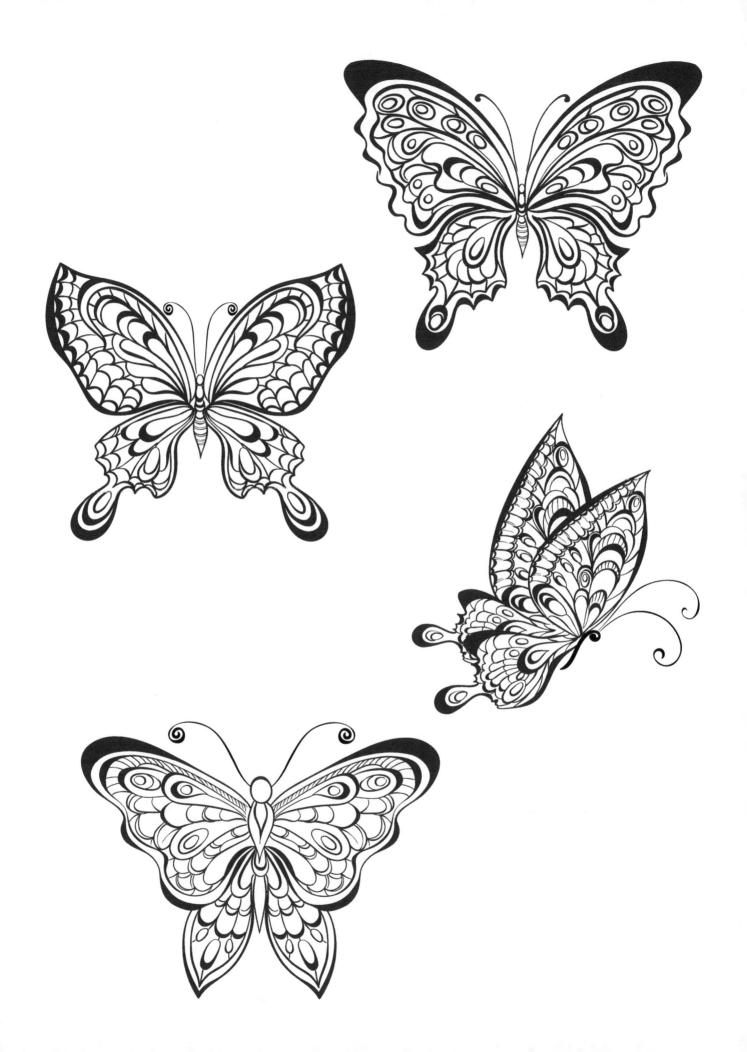

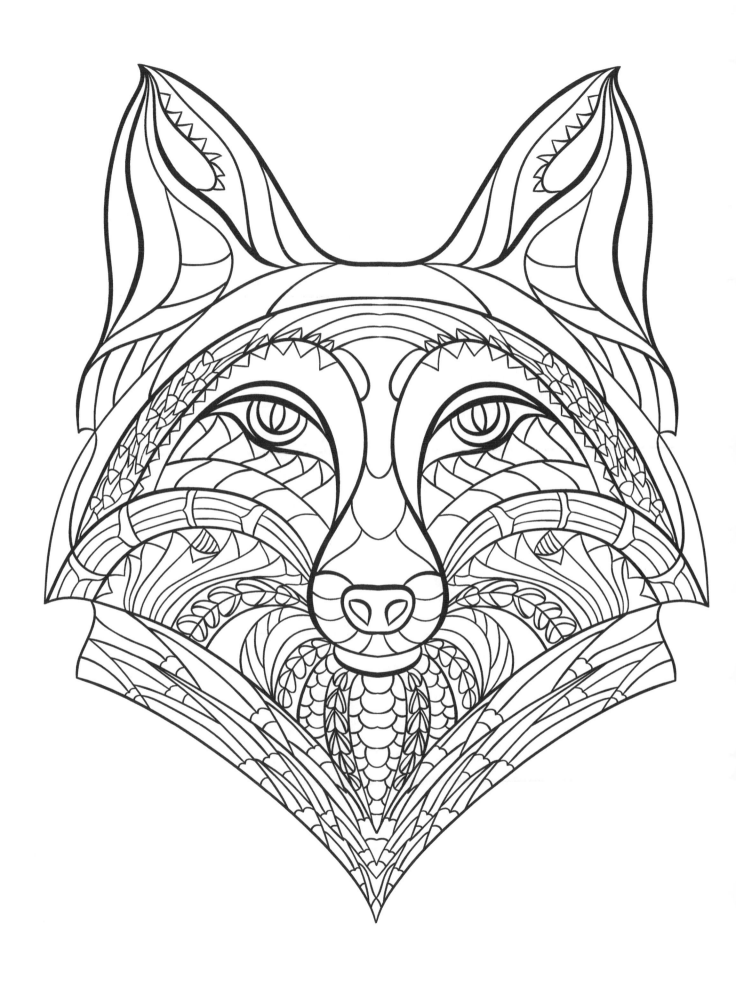

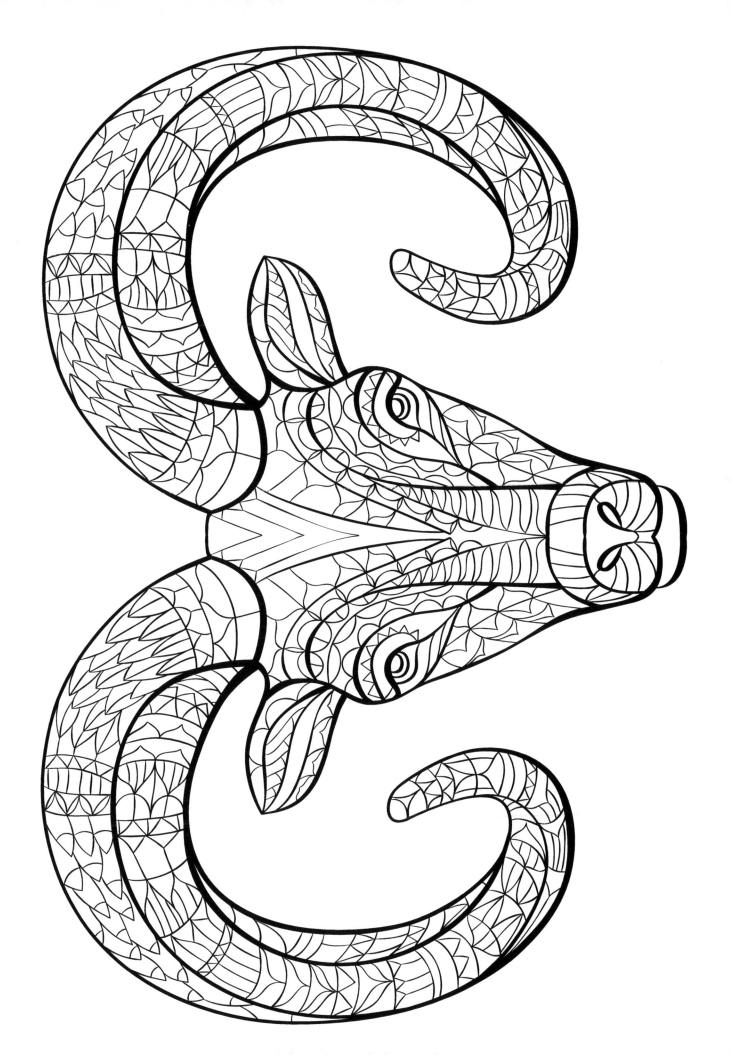

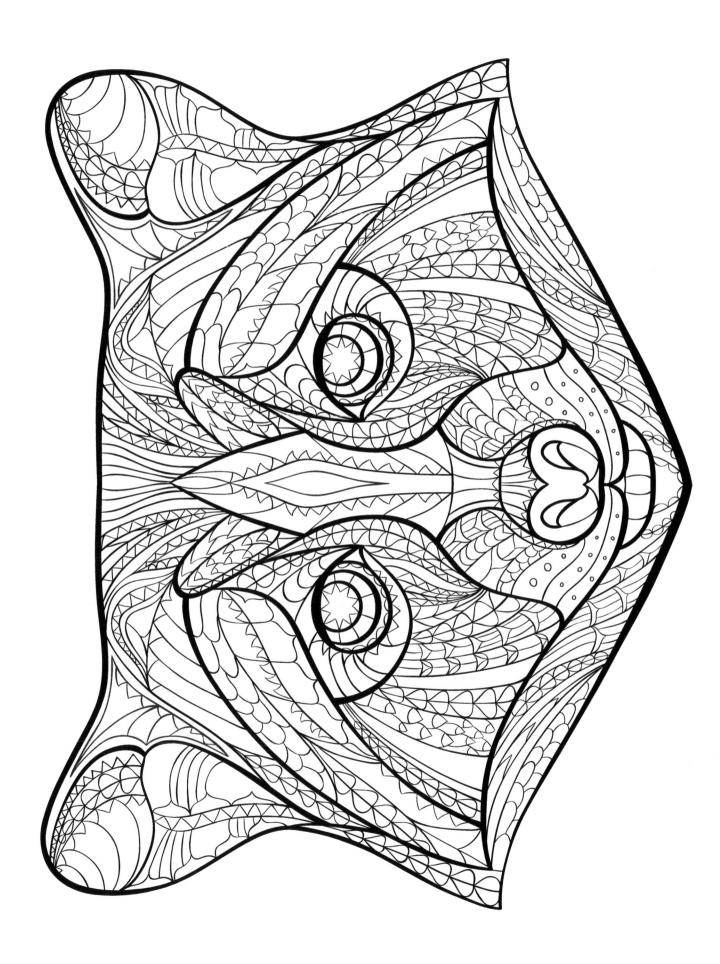

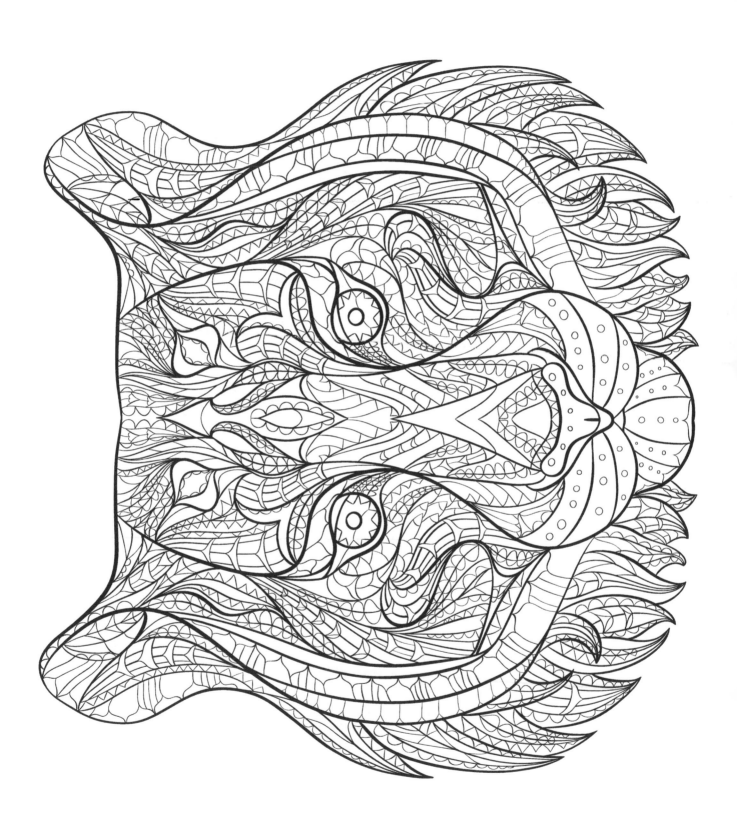

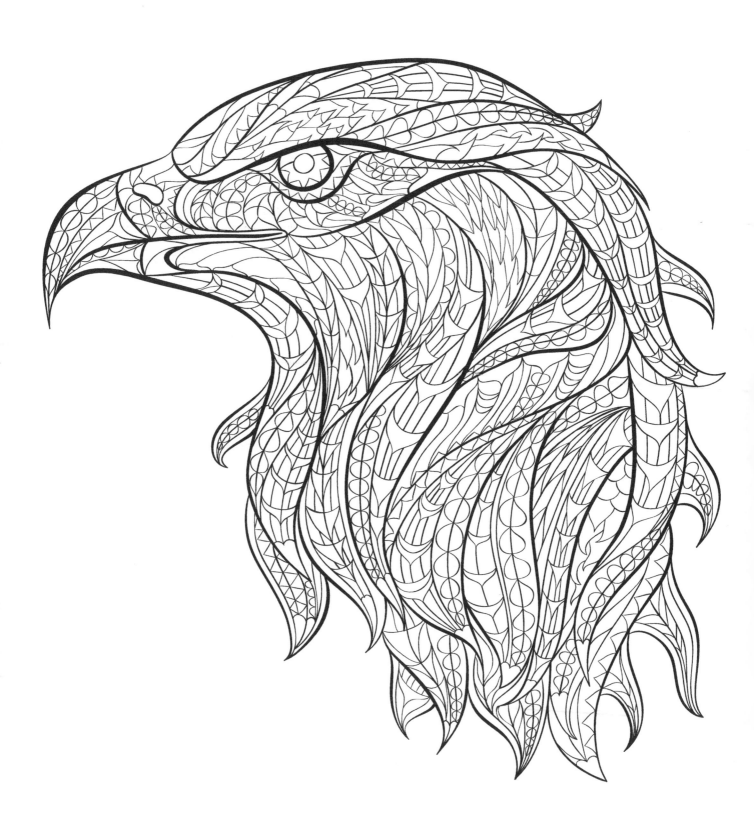

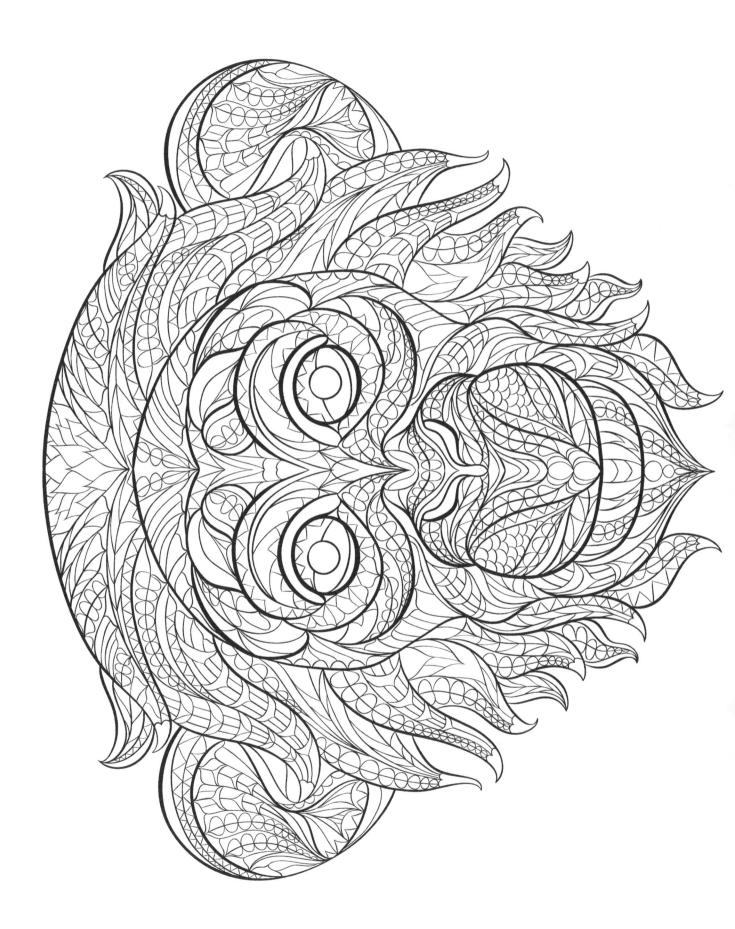

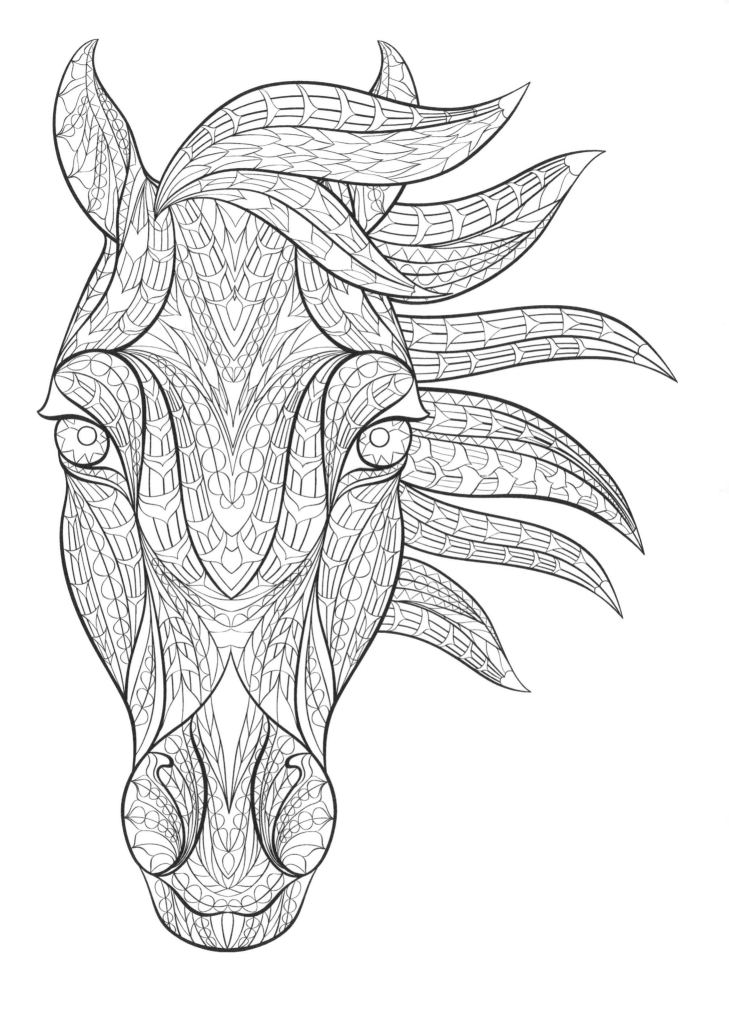

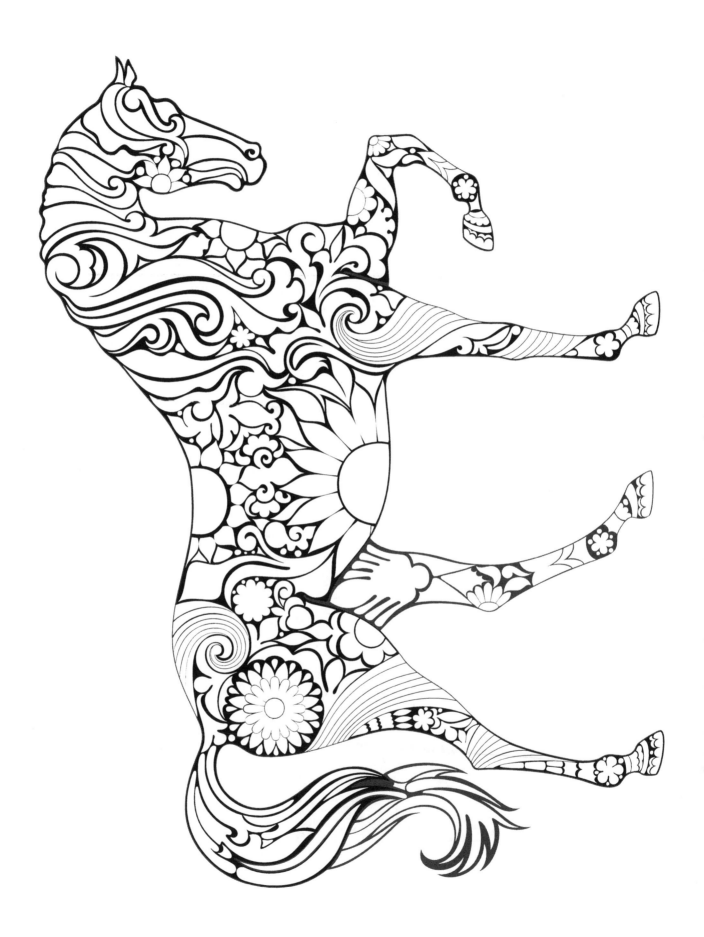

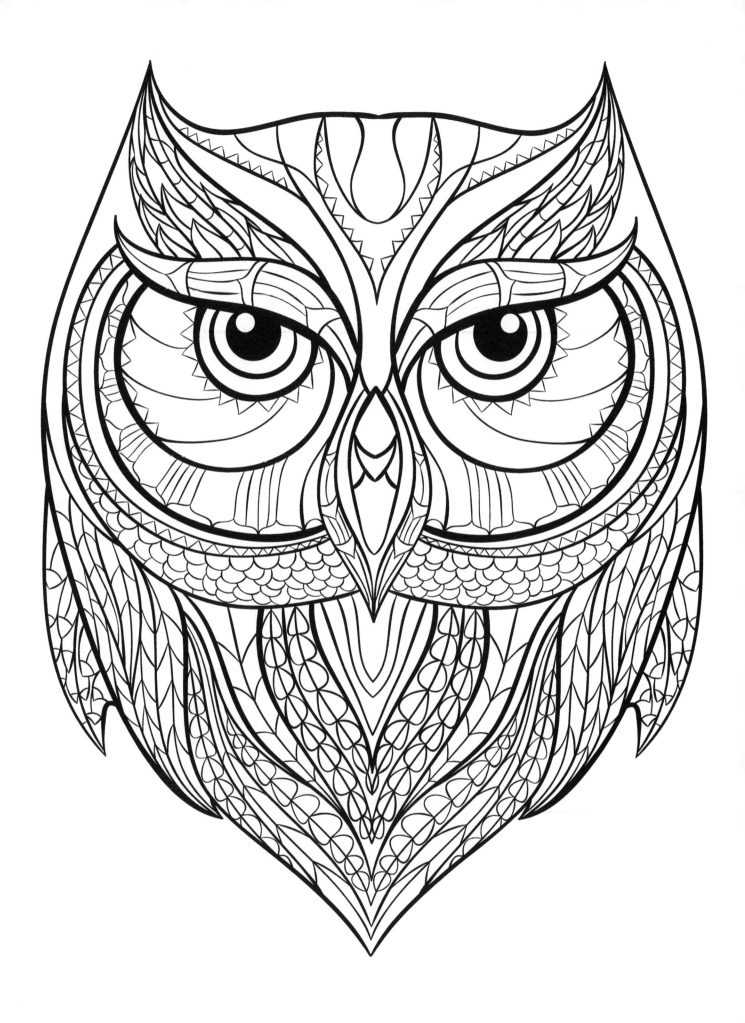

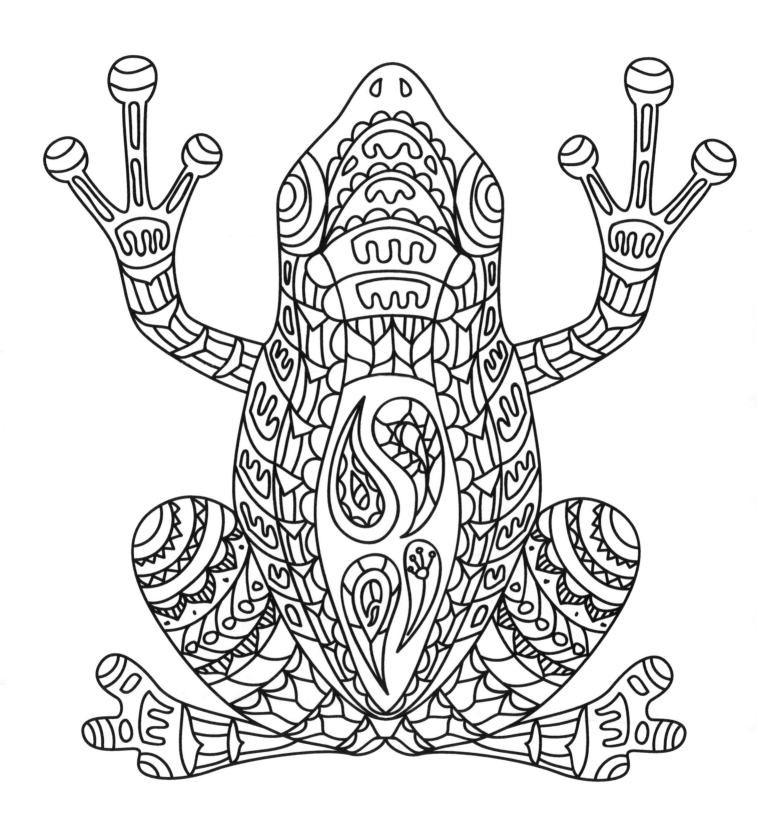

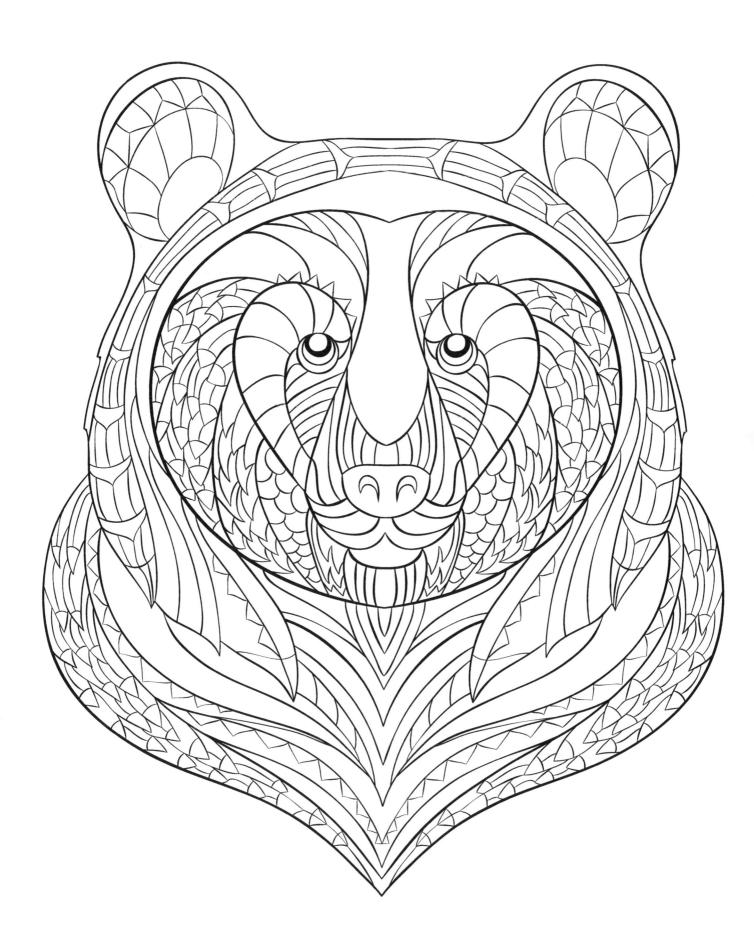

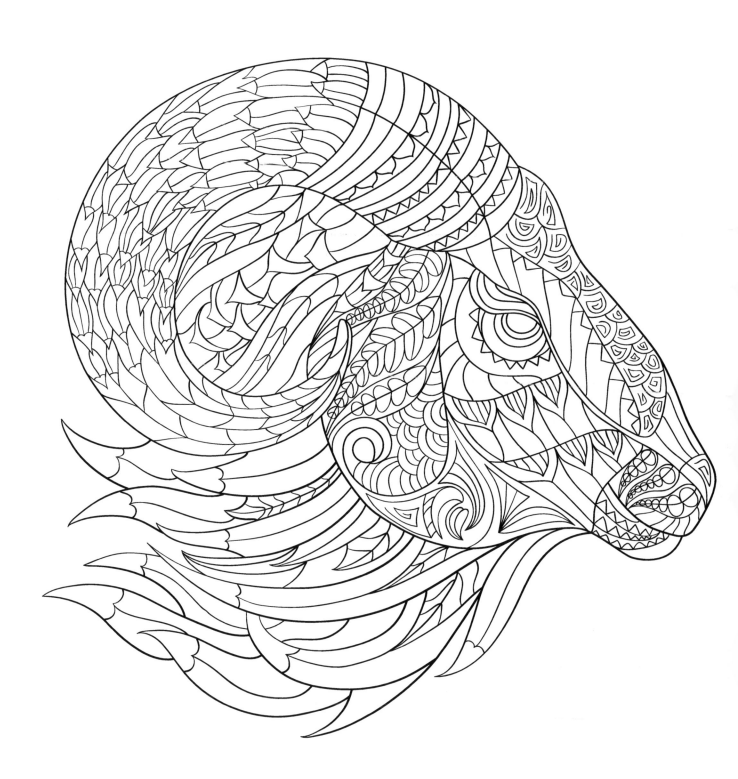

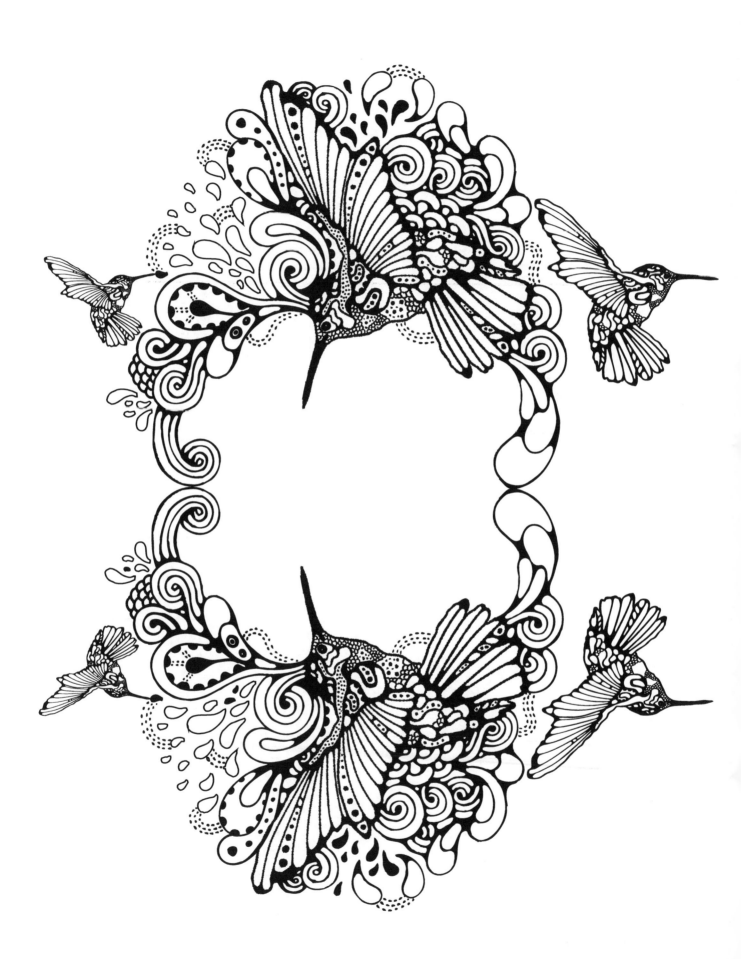

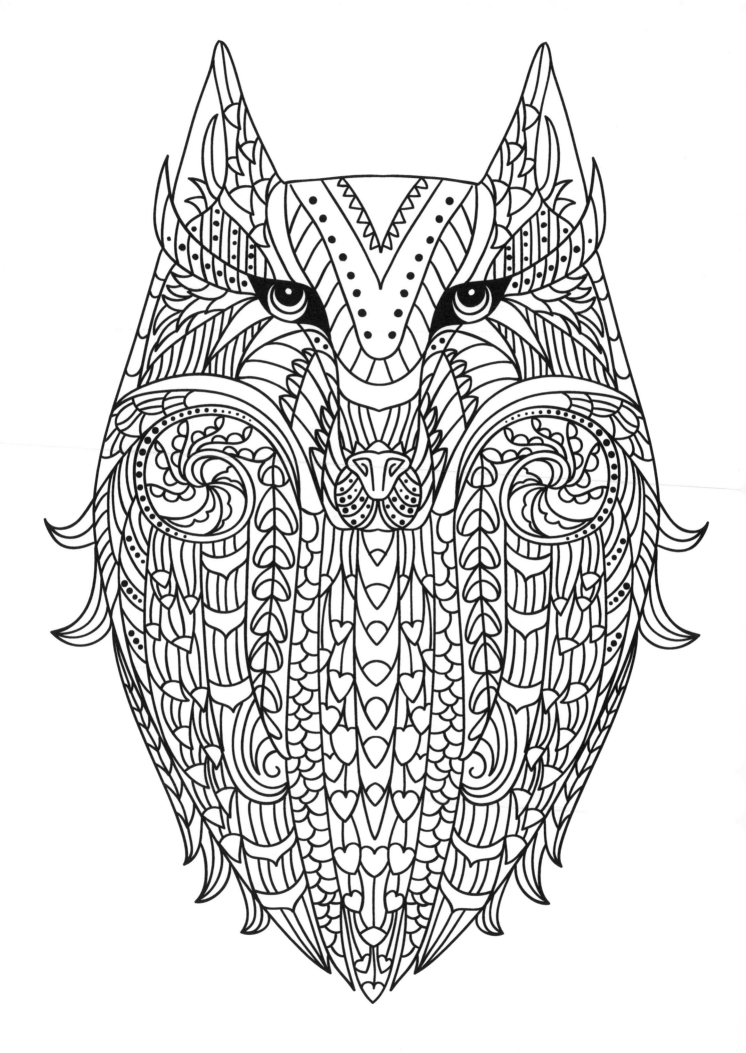

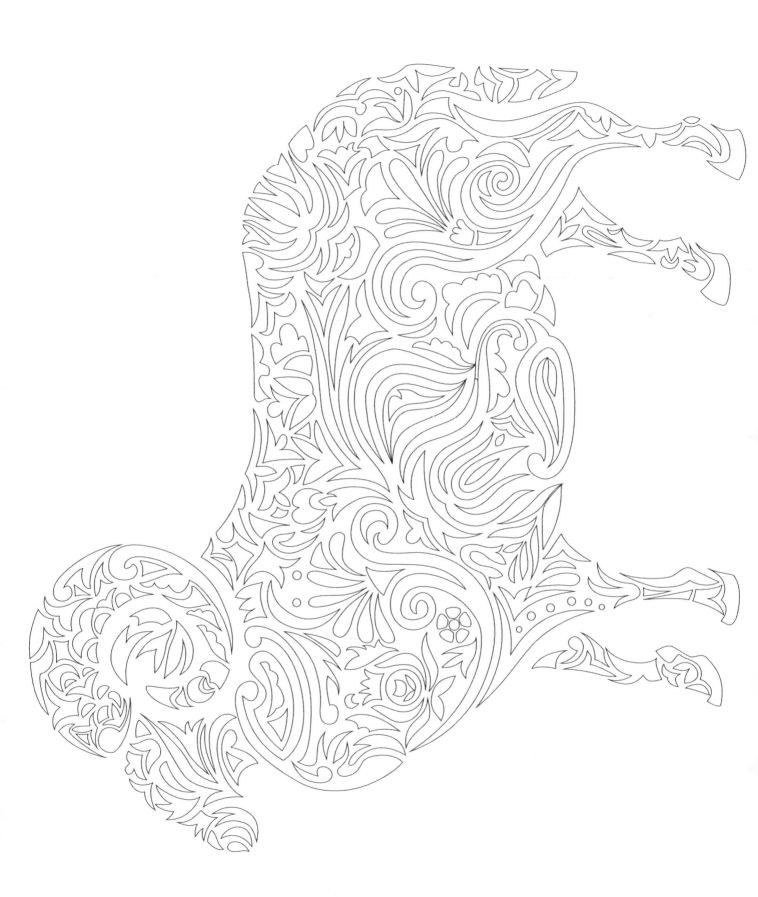

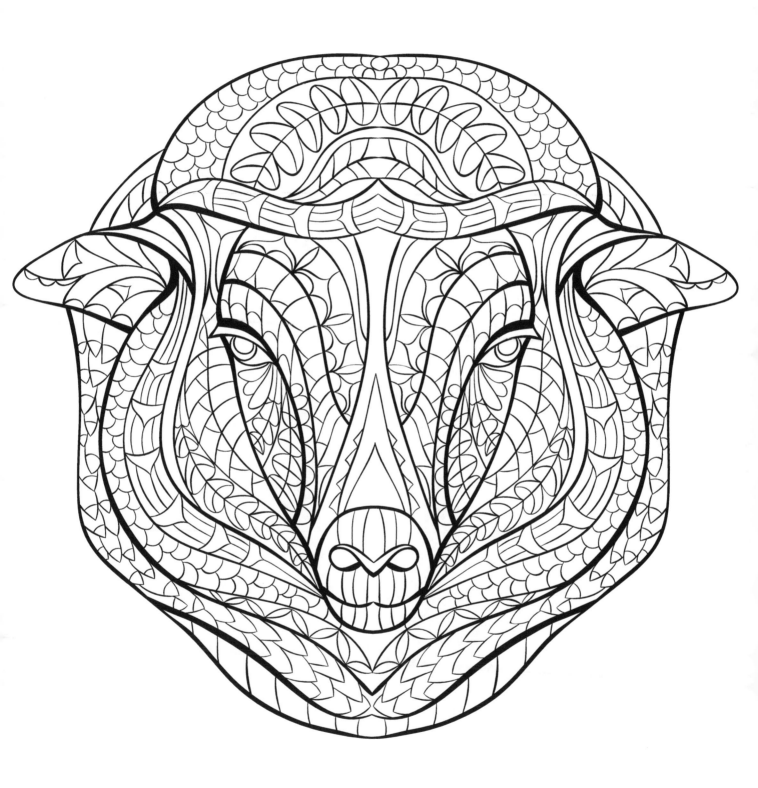

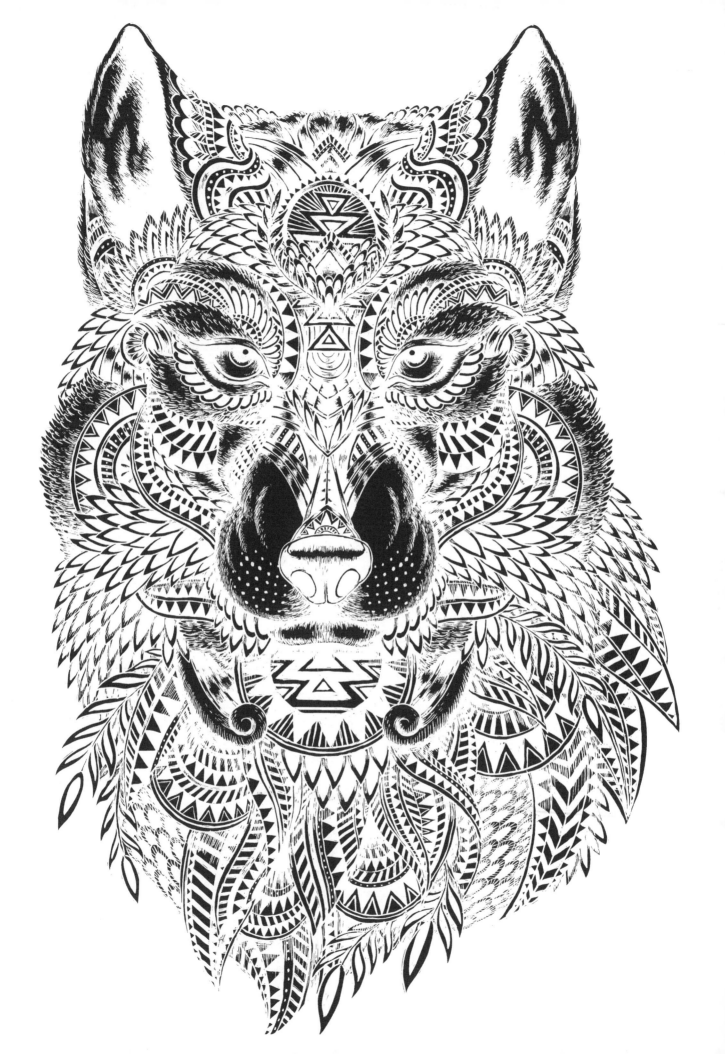

READY FOR THE NEXT ONE?

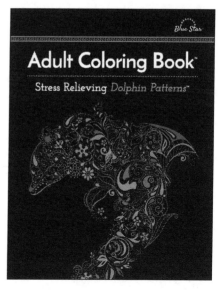

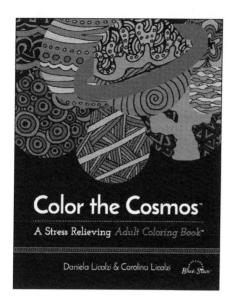

Color the Cosmos™

A Stress Relieving *Adult Coloring Book*™

Daniela Licalzi & Carolina Licalzi

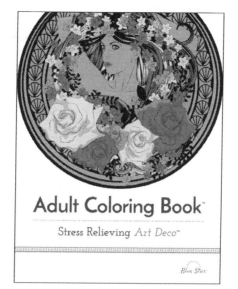

Adult Coloring Book™

Stress Relieving *Art Deco*™

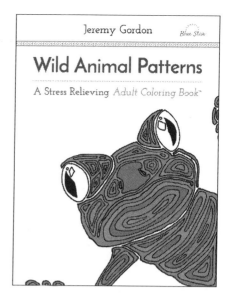

Jeremy Gordon

Wild Animal Patterns

A Stress Relieving *Adult Coloring Book*™

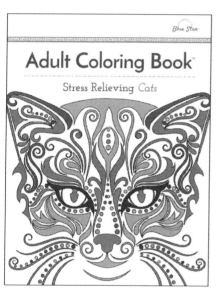

Adult Coloring Book™

Stress Relieving *Cats*

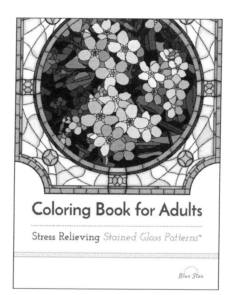

Coloring Book for Adults

Stress Relieving *Stained Glass Patterns*™

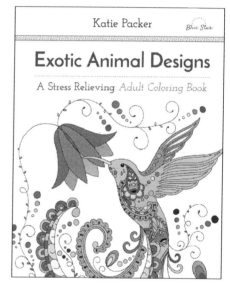

Katie Packer

Exotic Animal Designs

A Stress Relieving *Adult Coloring Book*

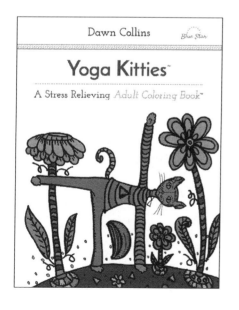

Dawn Collins

Yoga Kitties™

A Stress Relieving *Adult Coloring Book*™

Adult Coloring Book™

Stress Relieving *Kaleidoscope Patterns*™

Adult Coloring Book™

Stress Relieving *Paisley Patterns*™

Look for the *Blue Star*

bluestarcoloring.com

Made in the USA
Lexington, KY
03 January 2016